Pab

A Guide to
Postmodern Architecture
in London

Koenig Books, London

2008

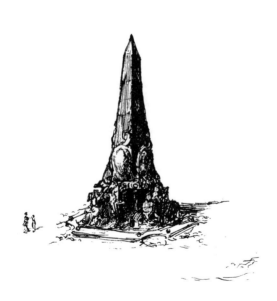

Introduction

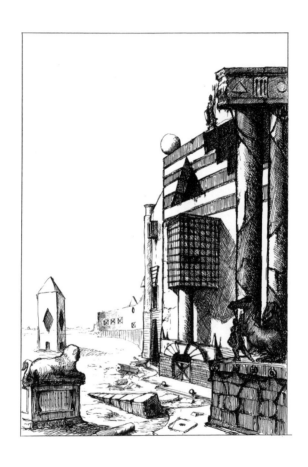

— Postmodern Landscape —

Portents and Prodigies,
are grown so frequent,
That they have lost their Name.

— John Dryden, *All for Love* —

Although postmodern architecture reaches giddy heights in the cinema multiplexes and shopping malls on the outskirts of town, its services have been in greatest demand in the centre of London. The fun, brash style dominated architecture from its radical inception at the end of the 1970's to its soggy death by cul-de-sac developments in the 90's. Why did the postmodern expire? A change of fashion, maybe? It can certainly be too much at times, all those Playdoh pediments, Lego walls and cheap multicoloured facings. A victim of its own popularity? We live and work in countless postmodern low-rise houses and offices all over the city; so ubiquitous is it that not a street has been spared.

The word postmodern never meant to signify a similarity of approach or intent on the part of its architects. From the onset it writhed in directions too convoluted for our purposes here. Luckily for us now, it has become a label under which a variety of trends can be seen together; as much an angry movement intending that new buildings preserve or create an idea of local historical character, as a cynical one facilitating corporate architectural identity. Some architects

regressed to a fantasy of pre-industrial society after the ravages of the social housing experiments of the previous decades. For yet others it was a playful celebration, a timely return to basic classical principals, or a wish that buildings act like billboards and communicate more directly with the person in the street.

Though the style – and it is a style – was touted as a 'return to history', its rupture with the Modern – its refusal of the recent past – was more in keeping with the spirit of the pioneering modern movement than with those who sought to preserve the embers of the Modernist tradition. The daring and newness of things such as prefabricated ornament made it impossible for ambitious young architects to withstand its allure in the early days. That said, the postmodern did not have an easy time at first, with the new generation of architects, Traditionalists, Modernists, the tabloids, Prince Charles, Lucinda Lampton and a merry bag of critics slinging muck at each other like characters in a Hogarth print.

It is hard for us to remember a time in which the rediscovery of beauty seemed imperative. What it must have been like to see wild colour splash the dull Brutalist face of London with an almost erotic intensity. How it must have seduced after those winters of discontent, race riots and rainy council-house esplanades. At the beginning of the 1980's the postmodern flourishing in the Capital appeared so very important that it seemed to mirror the inner land-

scape of our collective 'postmodern condition'. Looking out from green triangular windows some proclaimed that we had been suppressing architectural traditions and shared symbolic language that had been with us since the dawn of time.

For all the traditionalists and classicists, the key to the success of postmodern architecture lies in the aphorism: the cheapness of its construction versus the stories it is able to tell. Variations of style motifs pasted thinly onto steel frames make for the most obvious, direct, and cost-efficient differentiations of identity between it and neighbouring buildings; analogous to the role of advertising in establishing and communicating difference between products as efficiently as possible; Deco cinema, Greek temple, Edwardian baroque, Dallas courthouse, Gothic Minster, Alessi teapot etc. etc. The liberation of PoMo is the liberation of capital; unrestrained, joyous and mad. It was through postmodernism that architectural stories about business became romantic again. No coincidence that the postmodern jamboree climaxes at the centre of financial power – the City of London. Here one finds the most delirious pastiches, Byzantine luxuries and opiate-marbled façades. Observe the harlequin buildings in the City frozen in a dance of pre-crash euphoria, making more delicate souls feel as though there were really no one at the reins. As if it were all about to go wrong ...

* * *

The fear of the crash still brands the postmodern style, and assures our love of the architecture that was formed during our recovery from it. All those unsanded wood floors, all that 'good' design, the furniture with integrity, the fair-trade coffee. As lovers of culture we are perfectly catered for inside newer, more tasteful buildings. Postmodernism came along before we got better at tailoring buildings to suit markets demands. Times were brasher then, whereas now commercial, cultural, residential buildings appear so taste-ful as to render themselves invisible. What postmod-ernism's demise has taught us is how to refine a product. We now know, thanks to the 1980's, that culture can generate money and be an integral part of the economy. A portion of the blame for this lost innocence has, however, attached itself onto postmodern architectural forms.

In the increasingly hysterical competition between cities to attract visitors and business, politicians and busi-ness leaders know the importance of signature architects in generating a sense of lively notoriety and cultural debate. Wild skylines encouraged. In a seemingly opposite tendency heritage is produced or amplified, and grafted onto tourist sites, or to aid in gentrification. Buildings are restored, re-created, or pastiched. Streets are traditionalized, with cob-bles replacing asphalt. In these spaces, organic and haphaz-ard growth is mimicked by prefabricated set-pieces of capi-tal city. Public space gives way to a consumer-friendly mirage of public space, simulating diversity and choice. The piazza

provides a thin ornamented surface on which we can per-
form citizenship.

Today the value of older postmodern architecture lies
not its retro appeal but with what its initial success reminds
us of. Triumphal and empty, these buildings are old batter-
ing-rams that we have no use for anymore. Designed to in-
spire us with the glamour of finance, the conspicuousness
of their effort now looks gauche and, embarrassed, we have
discarded them. This is what lends these buildings an air of
pathos and tragedy; they have been abandoned by the very
ideology they helped on to victory. The dreamlike, distant
quality of those titanic lollypop offices on the London Wall
derives from a repressed memory of the vanquished alter-
natives of the old left. They were built at a time when those
alternatives still existed and reflect them in a sort of nega-
tive imprint.

However grandiloquently postmodern architects pined
to see their buildings as ruins, they must have been a little
taken aback that the ruination process was allowed to hap-
pen so fast. We have punished the style harshly, pretending
it isn't here and was never important. Without realising it,
however, this has turned out to be the biggest compliment:
proof of its having woven itself firmly into the fabric of our
city, and helping it survive here relatively unquestioned. The
drawings in this book are an attempt to document this mel-
lowing, but they also present the postmodern as it would
have liked to have been seen when new – aristocratically

integrated into the historical fabric, with age as its patina of success. Some of the buildings included in this book are iconic examples of the art – immodesties that we are all familiar with such as the National Gallery's Sainsbury Wing, or Charing Cross Station overlooking the Thames. Others are humble everyday structures that we pass by without noticing.

* * *

The Buildings

· Clore Gallery

Art Museum
Tate Britain, Milbank, SW 1

· Architect: James Stirling & Michael Wilford
· built: 1982 – 1986

The addition to the Tate Britain gallery in Pimlico, designed
to display a collection of Turner paintings, by James Stirling,
the father of British postmodernism. The enigmatic house-
shaped entrance forms the gaping mouth of a Cyclops about
to devour the unsuspecting art-lover. The window-frames
are finished in a specially commissioned 'Clore Green',
somewhere between apple and grass, while the walls play
with Mediterranean yellows and terracottas. Inside is a mar-
vel of the decorator's art, with at least 10 primary colours
vying with each other for dominance. The Clore has success-
fully sunk into its Edwardian surroundings but is a sadly
underused extension quietly awaiting a return of interest in
JMW Turner.

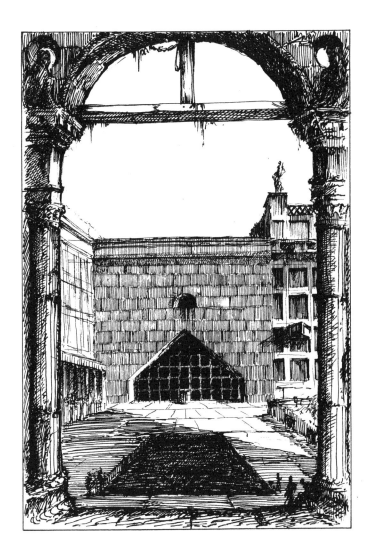

· Thematic House

Residential
Holland Park, W11

· Architect: Charles Jencks & Terry Farrell
· built: 1979 – 1985

A small-scale miracle in stucco, the redesign and extension of a typical Holland Park house by and for the spokesperson for local postmodernism, Charles Jencks. Although Jencks produced 'Symbolic Architecture', a book devoted to the house in 1985, this house treats the architect as the subject. The exterior customizes existing motifs and tonalities, exaggerating them. Faces are suggested by oversized chimneys and oriel windows. The interior is awash with inexpensive references to Wright and Mackintosh. Piles of MDF sculpted into skyscraper-shaped armoires and bathroom cabinets, and a chrome staircase representing the entire cosmos on its banister.

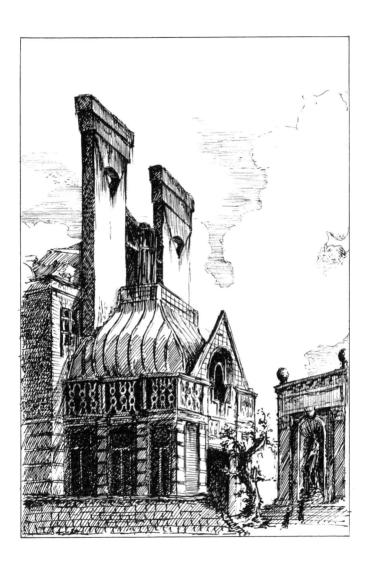

· TW-AM Breakfast Television Centre

Presently MTV Television Studios
Hawley Crescent, Camden Town, NW1

· Architect: Terry Farrell
· built: 1981 – 1982

Formerly home to TV-AM, the first daytime television chan-
nel in the UK, now housing MTV studios. Pioneering and on
the cheap, this was one of the first warehouse conversions in
the Capital. Brash execution reflected the company's off-
the-cuff programme format and temporary franchise. The
elaborate and over-sized metalwork keystone above the
entrance gate reverts the function of a keystone; needing
propping up in its own right. Walls of corrugated aluminium
layer upwards in art-deco curves. The symbol of TV-AM, the
eggcup, is turned into a finial and placed at intervals on the
canal façade in a display of heraldic pride. Every year another
eggcup was added to mark the ongoing success of the station.
There are ten in all. Sadly faded for many years, the gradat-
ing electric reds and blues of the façade have recently been
repainted.

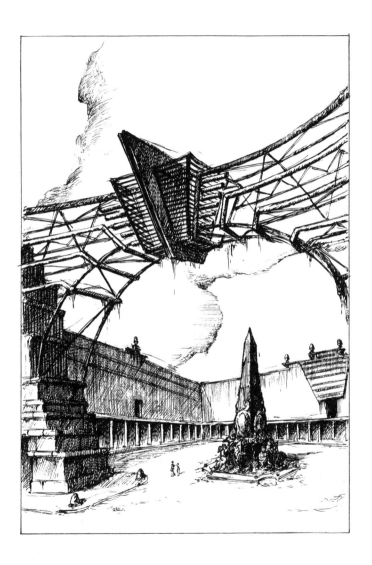

· Besso House and Eaton Terrace

Offices
Mile End Road, E1

· Architect: CZWG
· built: 1983

Yellow-brick neo-Georgian – curse of the postmodern – is given a witty repartee; a stucco neckline reveals a chest of black glass and aluminium. The office block is also surprisingly thin, and is bordered on either side by genuine developers' mock-Georgian houses. The cynicism, deliberate poverty and dark humour of the scheme heighten the area's Dickensian feel.

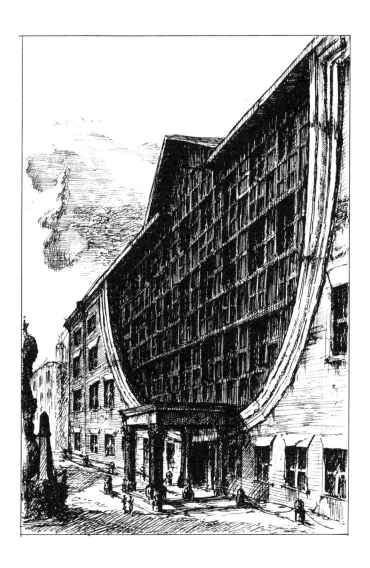

· Housing

Residential
Lanark Road, W 9

· Architect: Jeremy Dixon
· built: 1986

Cleverly designed flats posing as grand villas. The villas line
the street, continuing a sense of urban Victorian sophistica-
tion in an area that would have suffered from a larger scheme.
Brick and plaster, heaps of tradition and a playful poke at
social aspirations well suited to the neighbourhood.

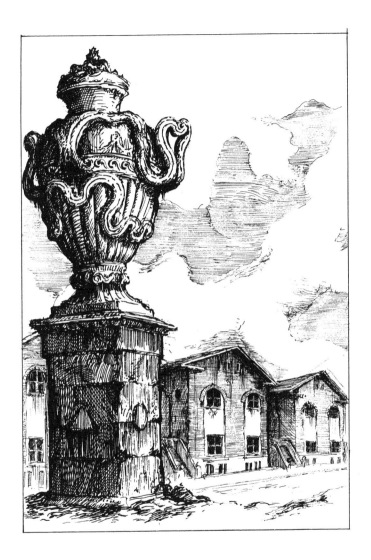

· HMV – Trocadero Complex

Mixed Retail
1 Coventry Street, Piccadilly, W1D 7DH

· Architect: Module 2
· built: 1987 – 1991

An easily ignored façade of ice-cream coloured stucco plastered onto an existing building. Possibly too shy for its setting at the heart of Piccadilly Circus.

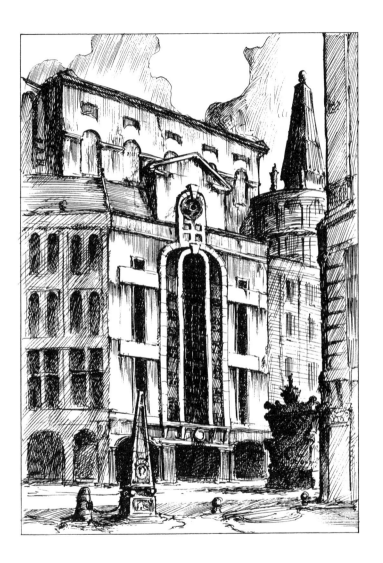

· Cascades

High Rise housing
2 – 4 West Ferry Road, Isle of Dogs, E14

· Architect:	CZWG
· built:	1986 – 1988

Confronting a stretch of river that has seen derelict industry replaced by luxury accommodation, Cascades evokes the ghosts of the dead with a fantasy on the theme of 1930's nautical engineering. This building was highly prized at the time by a new class of financiers known as Yuppies, being high-rise living a million miles away from local council tower blocks. The fizzy optimism of the Yuppie is celebrated in the jazz-age frivolity and ocean-liner detailing.

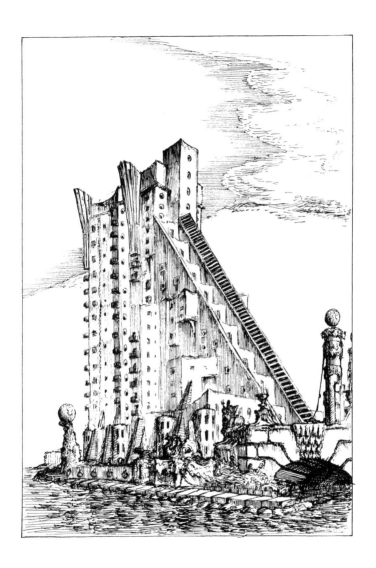

· The Circle

Mixed Residential / commercial
Queen Elizabeth Street, SE1

· Architect: CZWG
· built: 1987 – 1989

Another housing development for bank workers, boasting
over 300 apartments. Led by the charismatic Piers Gough,
CZWG create four odd owl-eared buildings that form a circle
around a plump bronze statue of a horse. The façades are
clad in blue lavatorial tiles, with small balconies swirling up
in diagonals. Bizarre.

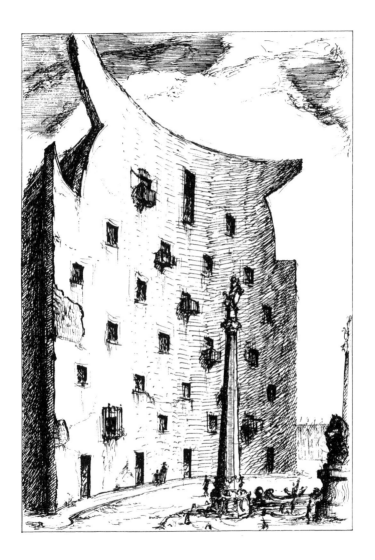

· Paternoster Square

Retail and Offices
St. Paul's, EC4M

· Architect: William Whitfield,
 Eric Parry + others
· built: 1996–2003

The redevelopment of a 1960's office complex adjacent to St Paul's Cathedral was the most bitterly fought-over commission in the Capital, with several high-profile walkouts, including a scheme championed by the Prince of Wales. Replacing concrete-slab offices are Tuscan colonnades, sweeping Portland Stone arcades, heritage brickwork, cafes, traditional streets, and myriad architectural styles simulating organic growth of the area. A 17th Century triumphal arch, brought out of storage and placed as an entrance to the complex, is so well integrated that its as if the square itself were blending into the past. At the centre of the piazza towers a Corinthian column crowned by a golden urn aflame with the spirit of regeneration.

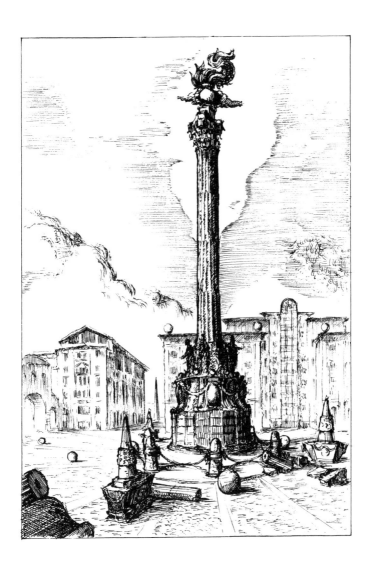

· Sainsbury Wing – National Gallery

Art Museum
Trafalgar Square, WC2

· Architect: Venturi Scott Brown & Associates
· built: 1987 – 1991

The extension to the National Gallery is the only postmodern
building in London that has been built to last. The thick
stone façade shows off a sober game of Mannerist humor:
columns dissolving into abstraction. The closed bridge link-
ing the old building to the new is a rotunda recalling an
Italian Renaissance temple. A grand neoclassical staircase
rises evenly up to the 1st floor. The appropriately sullen gal-
leries house the early masterpieces from the National
Gallery collection.

· Spec Office

Serviced offices
34–36 High Holborn, WC1X

· Architect: DY Davies
· built: 1986–1988

In spite of being plastered rather scantily onto the surface of a typical office building, a charming play of architectural elements attempts to be noticed. The street level incorporates a sculpture of a man by Eduardo Paolozzi in a central niche. The building fits in seamlessly with its equally historicist early 20th Century neighbours, demonstrating the affinities between Victorian high-street eclecticism and the less original examples of postmodern construction.

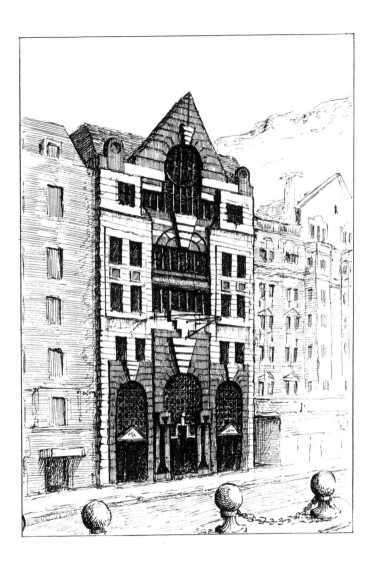

· Comyn Ching Triangle

Mixed development Residential / Offices / Retail
19 Shelton Street, Covent Garden WC2

· Architect: Terry Farrell
· built: 1979 – 1990

Seven Dials, a pasty antique (1989) sundial column stands at
the crossroad of seven streets. Facing the monument is this
large development. It incorporates individual historic hous-
es with shop-fronts along two streets, and is surmounted by
a red pivot corner tower cracking through the brickwork.
The triangular courtyard, enclosed by the rear ends of the
18th Century terraces, has gaudy new turquoise doors bor-
rowed from uninspired Oxford Colleges. Quite pioneering at
its conception, the development has spawned an army of
imitations.

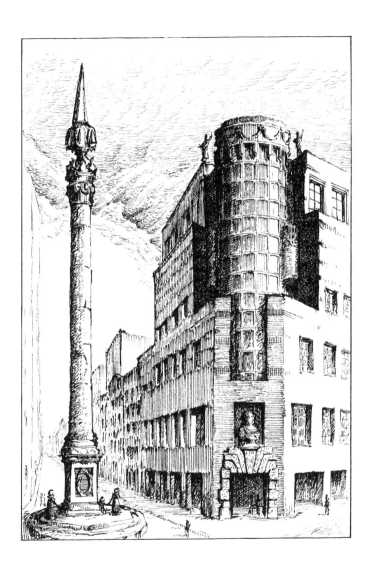

· Embankment Place

Train Station, Office, Retail
Charring Cross, WC2

· Architect: Terry Farrell & Partnership
· built: 1987 – 1990

A massive ornament facing the Thames, mimicking a tradi-
tional Victorian railway station. This romantic mixed-use
development looks back to a time when train stations were
not regarded as aesthetic objects. The curved hulk trans-
forms the skyline along the riverfront, heralding not only its
use as a train station, but giving character to the entire sur-
rounding area. Stalls selling mobile-phone accessories and
pirate DVD's has parasitically attached themselves to some
of the open-air galleries above street level, conjuring a Pira-
nesian disjunction between the grand and timeless and the
small and impermanent. Notwithstanding, the building up-
close feels like its made of cardboard in places.

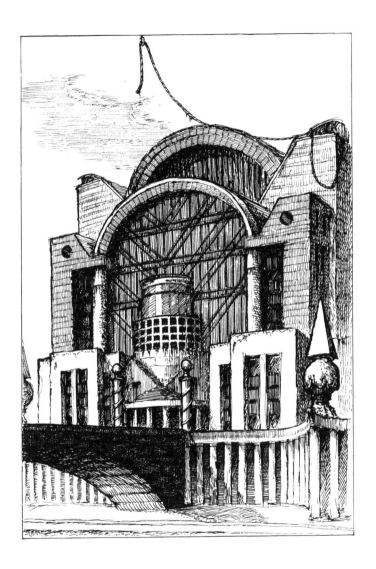

· Housing

Residential (169 Houses & Flats)
Shadwell basin, Wapping, E1

· Architect: MacCormac Jameson
 Pritchard & Wright
· built: 1986 – 1988

Holding their composure in front of a basin of still water is a
large series of low-rise houses built for enlightened and har-
monious citizens. Order, calm and dignity permeate the air.
A sense of unease springs from the architectural language of
public space, derived from 18th Century models, being uti-
lized in private developments.

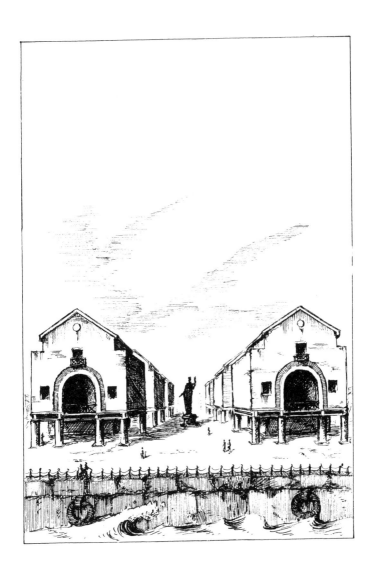

- Sun Alliance

Offices
Leadenhall court, 1 Leadenhall Street, EC3

- Architect: The Whinney, Mackay,
 Lewis partnership
- built: 1983–1989

A resplendent corner-piece with obeliscal trimmings in beige and brown. It boasts a curious feature; a row of granite sarcophagi lining the street under the arcade arches. During the 1980's the arcade made a timely reappearance in UK retail. Catering to a new, fussier client not content with shopping at BHS department stores and seeking a more individually tailored experience. The building sold in 2006 for £105,000,000.

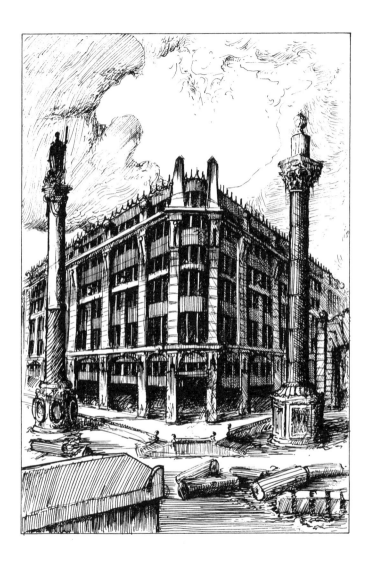

· King's Walk Shopping Mall

Retail
122 Kings road, Chelsea

· Architect: Damond Lock
 Grabowski Partners
· built: 1986 – 1988

A supremely bland shopping centre of brick and glass.

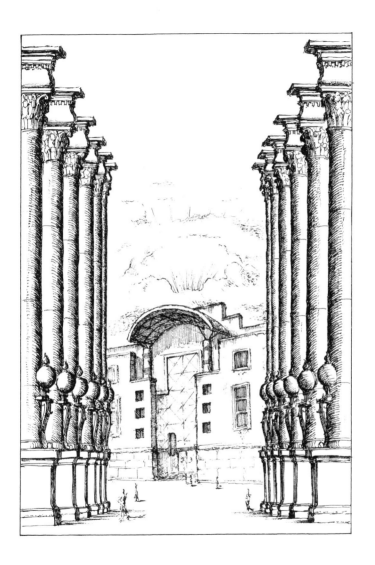

· Minster Court

3 Blocks of Office, Retail &
Restaurant for Prudential
Mincing Lane and Marc Lane, EC3

· Architect: GMW Partnership
· built: 1988–1991

Despite the fact that the 1980's were perceived at the time by
worried individuals as the dawn of a new medieval age, the
vast majority of city office and bank buildings are built in
classicist styles. Traditionally a language of architecture
associated with democracy, law and public institutions, clas-
sicism in the 1980's proclaims the Enlightenment and liber-
ation of the market. Here, however, we have a sinister, per-
pendicular office complex in a gothic style rendered in black
glass and salmon coloured granite. A mysterious world of
attic eaves and the low arch, shadows and cloisters hidden
from view.

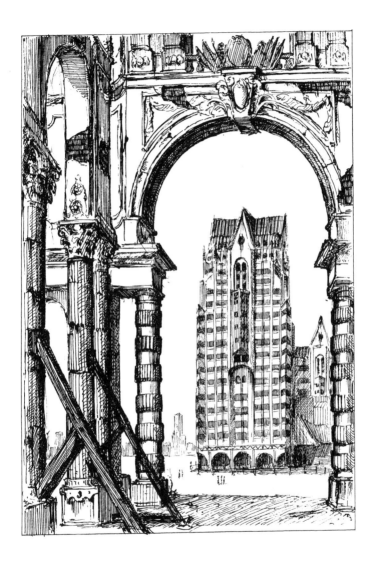

· Janet Street Porter's House

Residential / Office
44 Briton Street, Smithfield, EC1

· Architect: CZWG
· built: 1986 – 1987

A small-scale exercise in odd and obscure references built for the inventor of youth television, Janet Street Porter, and legendary television presenter, Normski. Diamond panes of glass, an Old Seville gated balcony, concrete log beams, and most witty of all, banded brickwork, usually employed to create strict visual planes in a building, but here blending into each other in four succeeding tones from dark to light. This touch of Gaudi in a dull backwater is situated at the heart of the Clerkenwell Miracle; the first defunct industrial area of the inner city since the war to be regenerated by a cultural elite closely followed by a hoard of investors. The move to the suburbs ended here for the fashionable.

· Marco Polo House

Offices
Queenstown Road, SW8

· Architect: Ian Pollard
· built: 1986–87

Successively home to the Observer – a newspaper champi-
oning good liberal taste –, several ill-fated digital television
channels, and now QVC, the home-shopping empire. This
trashy palazzo in black glass and the thinnest stone veneer
blends the baroque with the design integrity of a car-show-
room. It is often regarded as the most vulgar building in
London, if it is to be considered a building at all.

· Vauxhall Cross

Offices (400,000 Sq. Ft of office space)
80–85 Albert Embankment

· Architect: Terry Farrell Partnership
· built: 1986–1987

Another monumental set-piece by Farrell. This time a home for MI5, the secret service, in the incognito guise of an Aztec pyramid looming over the Thames. Fabricated out of a cast beige substance and green mirrored glass, the building is grandiose. The path along the south bank of the Thames passes gingerly in front of it, under the gaze of the cameras. As a concession to the passerby, a drab assortment of gazebos and jazzy street furniture transforms the site into a disused pleasure garden. Vauxhall Cross is a drama of a building that celebrates not only its use, but the emotional associations it generates. For a while the stepped façade was dotted with clipped and potted yew trees. These were clearly deemed inappropriate.

· No. 1 Poultry

Office & Retail
No. 1 Poultry, Bank, ECR 8JR

· Architect: James Stirling & Michael Wilford
· built: 1988 – 1998

The most notorious building of the London postmodern, and
the last by James Stirling, completed after his death. Distinc-
tive rhubarb-and-custard striped cladding and a jagged and
complex array of window bays and colonnades is built around
a blue tiled circular courtyard. At the front, a grand entrance
portal with a rather dramatic cornice, and a masonry turret
bearing a clock. The best is at the top, however, with a
Conran-designed restaurant popular with city financiers,
appropriately named the Coq d'Argent, abutting two roof
gardens. The first, a circular cloistered garden with orna-
mental benches canopied by fruit trees. The other, on the
building's prow, is a spectacular garden in a formal French
style replete with a clipped shrubbery parterre overlooking
the Bank of England. Voted the 5th worst building in London
by Time Out readers, it will be adored in years to come.

· Alban Gate

Office & Retail (380,000 Sq Ft , 18 Storey)
London Wall, EC2

· Architect: Terry Farrell Partnership
· built: 1987 – 1991

A pink and grey granite monster of epic proportions hogging
an entire street in the financial district. The magnificently
grim entrance tunnel is dingily illuminated by the glow of a
Pizza Express sign. The tunnel leads to probably the deadest
area in the City – the traffic roundabout in front of the
Museum of London.

· No. 200: Clifford Chance

Currently empty offices (under renovation)
London Wall

| · Architect: | Fitzroy Robinson Partnership |
| · built: | Proposed in 1983 built in modified form in 1991 – 1992 |

Straddling the west side of the roundabout opposite the Museum of London, are the baubled minarets of No. 200. More stage-design than architecture, the Babylonian splendour of the stepped pyramid towers over a multitude of little streets. Coldly impervious to the financial crash in the late 1980's and the ensuing sobriety of new office-buildings, the pendulum of fashion has swung again and the development is currently being restored.

· Canary Wharf Tower – 1 Canada Sq.

Office
Isle of Dogs, E14

· Architect: Cesar Pelli & Associates
· built: 1987–1991

This King of towers is the centerpiece to the project spon-
sored by Margaret Thatcher to found a new capital of finance
on top of piles of burning rubbish and forgotten industrial
wastelands to the east of the city. The tower is thus occasion-
ally known as 'Thatcher's erection'. Taking the form of a
grand funerary obelisk, as befits its distance from every-
thing, the edifice marks the end of the playful postmodern in
the banking world, and a more mature optimism for London
as a global financial centre.

· Four Seasons Hotel

46 West Ferry Circus, Canary Wharf, E14 8RS

· Architect: Phillipe Starck
· built: 1998

Ever since the early 19th Century the Egyptian style has been a perennial favourite in London. Cryptic, mysterious, grand, this luxury hotel designed by signature architect Philipe Starck endeavours to raise fun postmodernism from the dead. It boasts a massive Luxor-style roof of green alumi-nium, protruding windows and a pair of multi-storey non-functional 'doors' propped half open as if an excavation were in progress. Set in the new Docklands, the hotel evokes the oldest home of money; that of the Valley of the Kings, and ambitiously announces the current success of the financial capital as deserving of tourist attention in its own right.

An ABC of
Postmodern Detail

Arcades

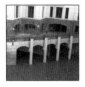 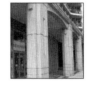 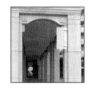

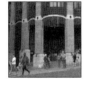 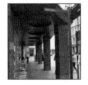 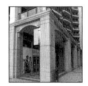

Arches

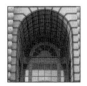 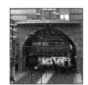

Arches

Atriums

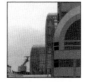 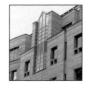 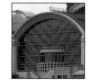

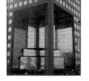 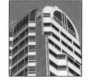 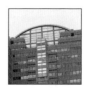

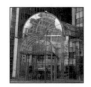 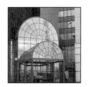 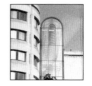

Balconies

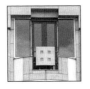 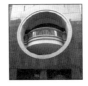 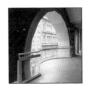

Balls

 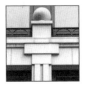

Balls

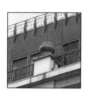 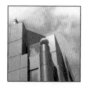 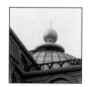

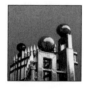 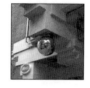

Bays

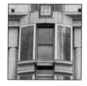

 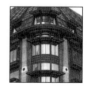

Bays

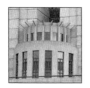 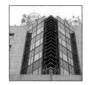 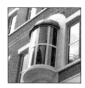

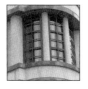 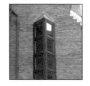

Brick

 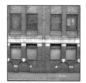

Centrepieces

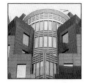 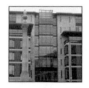 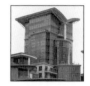

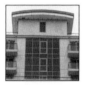 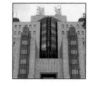 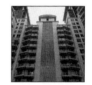

Clocks

 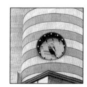

Columns

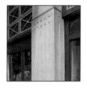 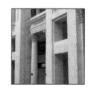

Columns

Corner Towers

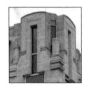 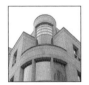 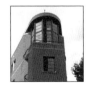

Corner Towers

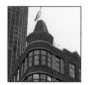 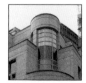 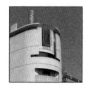

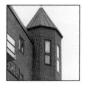 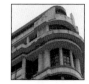 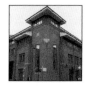

Cornice

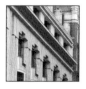 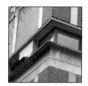

Cornice

Cupolas

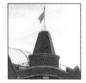

Dates

Doors

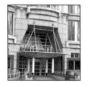 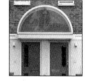

Doors

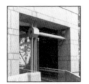 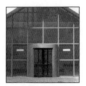

 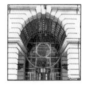 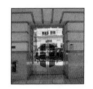

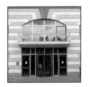 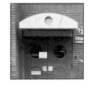 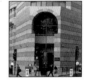

Doors

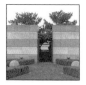 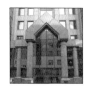 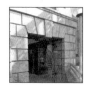

Eaves

 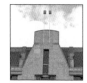 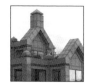

Furniture

Furniture

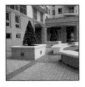

Garages

 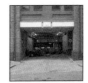 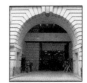

Ironwork

Ironwork

 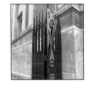

Keystones

Lights

 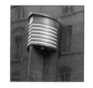

Masonry

Masonry

 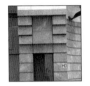 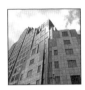

 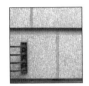 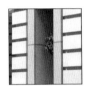

Misc. Ornamentation

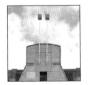

Misc. Ornamentation

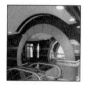 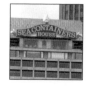

 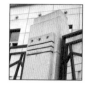

 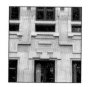

Obelisks

Pavillions

 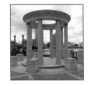 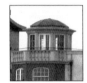

Paving

Pediments

Pediments

 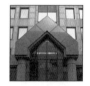

 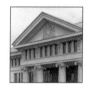

Round Windows

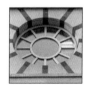 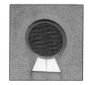

Round Windows

 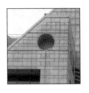 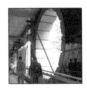

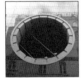 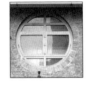

Round Windows

 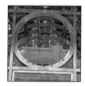

Sarcophagi

Stairs and Escalators

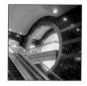 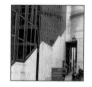 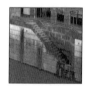

Statuary

Statuary

Triangles and Pyramids

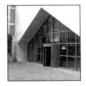 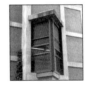 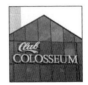

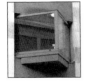 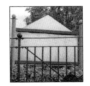 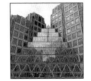

Triangles and Pyramids

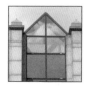 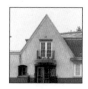 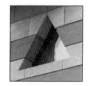

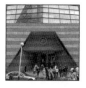 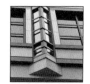

Windows

Windows

 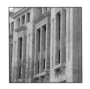 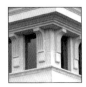

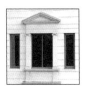 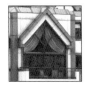 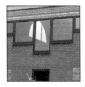

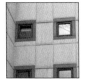 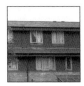 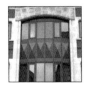

I would like to thank Leo Boix, Herald St., Uwe Koch,
Franz König, Franco Noero, Paul Richards, and in
particular Polly Staple and Catherine Wood, to whom
this book is dedicated.

This 2nd edition has been
published on the occasion of
Pablo Bronstein's exhibition
Sketches for Regency Living
at the ICA London, 2011

—

© 2008 Pablo Bronstein
and Koenig Books, London
2nd Edition 2011

PHOTOGRAPHS
Maria Benjamin and
Pablo Bronstein

DESIGN
Silke Fahnert, Uwe Koch, Köln

PRODUCTION
Druckerei zu Altenburg

—

FIRST PUBLISHED BY
Koenig Books, London

—

ISBN 978-3-86560-173-5

DISTRIBUTION

Buchhandlung Walther König,
Ehrenstr. 4, 50672 Köln,
Tel. +49 (0) 221 / 20 59 60
Email: verlag @ buchhandlung-
walther-koenig.de,
www.buchhandlung-walther-
koenig.de

—

DISTRIBUTION
OUTSIDE EUROPE

D.A.P. / Distributed
Art Publishers, New York,
155 Sixth Avenue, 2nd Floor
New York, NY 10013, U.S.A.
Tel: +1 212-627-1999
Fax: +1 212-627-9484